CONTENTS

D1114697

FOREWORD

The National Gallery contains one of the finest collections of European paintings in the world. Open every day free of charge, it is visited each year by millions of people.

We hang the Collection by date, to allow those visitors an experience which is virtually unique: they can walk through the story of Western painting as it developed across the whole of Europe from the beginning of the Renaissance to the end of the nineteenth century – from Giotto to Cézanne – and their walk will be mostly among masterpieces.

But if that is a story only the National Gallery can tell, it is by no means the only story. The purpose of this new series of Pocket Guides is to explore some of the others – to re-hang the Collection, so to speak, and to allow the reader to take it home in a number of different shapes, and to follow different narratives and themes.

The wide variety of faces to be met on the walls of the Gallery raises fascinating questions about the intentions of the artists who have tackled human physiognomy over the centuries, about how they have conveyed the personalities of their subjects, and about how we, in turn, interpret characteristics and expressions. Flowers and fruit are as universal in their appeal as the human face, and they too are to be found in profusion throughout the Collection. Perhaps less immediately accessible to us today are the messages they were intended to communicate to the viewer, who can trace their changing symbolism, as well as the development of many of their species, whether instantly recognisable or unfamiliar.

These are the kind of subjects and the questions the Pocket Guides address. Their publication, illustrated in full colour, has been made possible by a generous grant from The Robert Gavron Charitable Trust, to whom we are most grateful. The pleasures of pictures are inexhaustible, and our hope is that these little books point their readers towards new ones, prompt them to come to the Gallery again and again and accompany them on further voyages of discovery.

Neil MacGregor, DIRECTOR

POCKET GUIDES

FACES

Alexander Sturgis

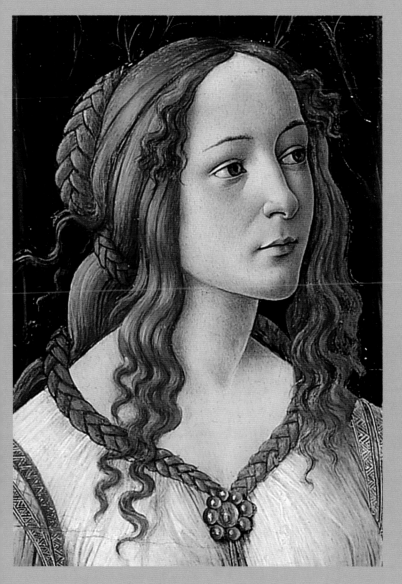

NATIONAL GALLERY PUBLICATIONS LONDON

DISTRIBUTED BY YALE UNIVERSITY PRESS

This publication is supported by
The Robert Gavron Charitable Trust

THE POCKET GUIDES SERIES

OTHER TITLES
Allegory, Erika Langmuir
Conservation of Paintings, David Bomford
Flowers and Fruit, Celia Fisher
Frames, Nicholas Penny
Landscape, Erika Langmuir

FORTHCOMING TITLES
Angels, Erika Langmuir
Colour, David Bomford and Ashok Roy
Impressionism, Kathleen Adler
Saints, Erika Langmuir

PICTURE CREDITS
18. Photo © Archivi Alinari.
36. Charles H. and Mary F.S. Worcester Collection. Photograph © 1998,
 The Art Institute of Chicago. All rights reserved.
38. Private Collection.
49. By courtesy of the National Portrait Gallery, London.
84 and 85. Photo © RMN.

Front cover: Details from the following illustrations, from left to right:
81, 32, 47, 23, 25, 43, 51, 66, 2, 82, 45, 46, 35, 71, 15, 61.
Title page: Detail from *Venus and Mars* by Sandro Botticelli.

First published in Great Britain in 1998 by
National Gallery Publications Limited
St Vincent House, 30 Orange Street, London WC2H 7HH

ISBN 1 85709 222 8

525285

British Library Cataloguing-in-Publication Data.
A catalogue record is available from the British Library.
Library of Congress Catalog Card Number: 98-67957

Edited by Rosemary Amos, John Jervis
Designed by Gillian Greenwood
Printed and bound in Germany by Passavia Druckservice GmbH, Passau

INTRODUCTION

When we meet someone the first thing we look at is their face. We look to see if we recognise the person, or for clues to mood and character. In an instant we might detect a family resemblance or notice signs of embarrassment or ageing, of high blood pressure or a five-o'clock shadow. We do this instinctively and are very good at it. We also bring this astonishing sensitivity to living faces to those that we meet in paintings. It is natural for us to read character into portraits or respond to the expressive faces in narrative scenes. Occasionally we even come across faces we know – most of us must have had the experience of recognising a friend or relative in some unlikely painting. A now-retired National Gallery warder, for example, can still be found among the

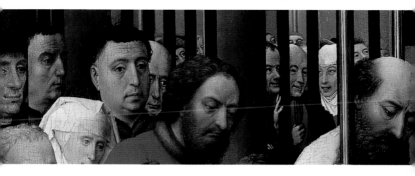

witnesses in *The Exhumation of Saint Hubert* as painted by Rogier van der Weyden in the fifteenth century [1].

1. Detail from *The Exhumation of Saint Hubert*, about 1440, by Rogier van der Weyden.

But faces in paintings are *not* the same as those we meet in real life. Faces communicate much of what they tell us through movement – a flashing smile or a tensing jaw – but paintings cannot move. And while there are some faces in the Gallery we might recognise, or others we know to be portraits, there are some faces we know we will never meet in the real world. The face of Botticelli's Venus [title page], for example, could only exist in a painting.

This book looks at some faces in the National Gallery's paintings – not just faces in portraits, but faces in a wide variety of different types of paintings. It is about why they look as they do, and how they communicate with us.

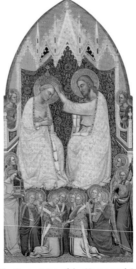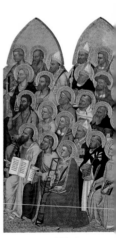

2. Attributed to Jacopo di Cione, *The Coronation of the Virgin and Adoring Saints*, 1370–1.

Of all the paintings in the National Gallery few are more crowded with faces than two pictures separated by more than two-and-a-half centuries. In both paintings over fifty faces – arranged more or less formally in row upon row – battle for our attention. But there the similarities end. *The Coronation of the Virgin and Adoring Saints* attributed to Jacopo di Cione [2, 3]

3. Detail of 2.

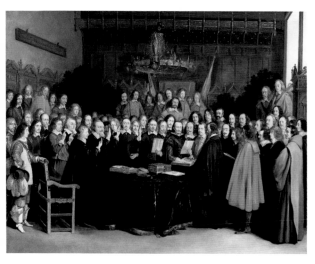

4. Gerard ter Borch, *The Swearing of the Oath of the Ratification of the Treaty of Münster*, 1648.

formed the main part of an enormous altarpiece painted between 1370 and 1371 for the Church of San Pier Maggiore in Florence and represents Heaven. In contrast Gerard ter Borch's much smaller painting of 1648 showing *The Swearing of the Oath of the Ratification of the Treaty of Münster* [4, 5] records an actual event. These two works were painted for very different reasons and in very different ways; yet the multitude of faces each contains presented the two artists with a similar problem, and the contrast in their treatment of these faces is revealing.

The saints that flank Christ and the Virgin in Jacopo's altarpiece are distinguished from each other in a number of ways – most obviously in the clothes they wear and what they carry. At first glance their faces also appear to have been individualised: pale-faced youths kneel next to swarthy old men; the bearded flank the close-shaven. But if we ignore the variety of hairstyles and complexions and instead concentrate on the features, it becomes apparent that we are looking at a simple and repeated formula. All the noses of the various saints present the same straight profile, and all the saints look towards Christ and the Virgin through the same almond-shaped eyes. Although hair may recede on some heads and beards sprout from others, this is a superficial variety – a selection of disguises assumed by the same impersonator.

7

In ter Borch's picture the difference could not be greater. Here, despite the small scale of the painting, we find faces in all their natural and imperfect variety. Noses vary from the snub to the aquiline, and the angular and thin-faced are juxtaposed with the chubby cheeked and double-chinned. It would seem that the artist is not merely tinkering with a formula but recording the features of real people. As it happens, we know this to be the case. Ter Borch was in Münster when the oath was sworn that brought to a formal end the war between Spain and the United Provinces of the Northern Netherlands. He painted a number of individual portraits that still survive of the various delegates, allowing us to identify many of the people in this painting. He even included himself – with reddish hair – at the extreme left staring out of the picture as a witness to the event. But even if we knew nothing of these circumstances, the variety of

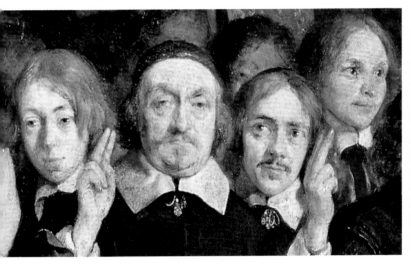

5. Detail of 4. faces within it would suggest that they are portraits – records of real faces – just as we would be sure that Jacopo's faces are not.

There are paintings where these two contrasting approaches to the face – the individualised and the stereotypical – can be seen side-by-side; for example the fifteenth-century Spanish painting, *Saint Michael triumphant over the Devil*, by Bartolomé Bermejo [6]. This was originally the central panel of an altarpiece whose donor, Antonio Juan, is shown kneeling at the archangel's feet. That the face of Antonio is a portrait

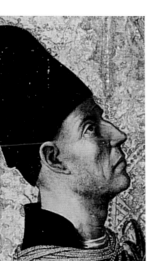

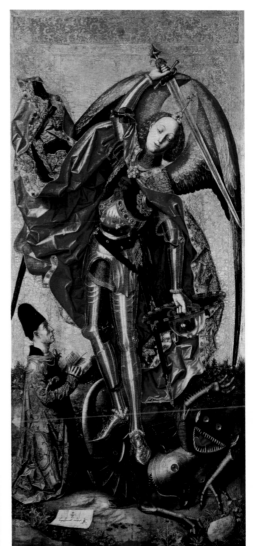

and that of Saint Michael an invention is to be expected; but even disregarding the difficulties of finding an archangel to pose for you, the manner in which the two faces are painted reveals a difference of approach. The contrast is between the conventional and the idiosyncratic – the unexpected kink in Antonio's nose, the furrow of his brow and the stubble on his chin [7], as opposed to the oval of Saint Michael's face, the elegant arch of angelic eyebrows and the pink symmetry of his lips. This contrast is much easier to recognise than to describe.

6. Bartolomé Bermejo, *Saint Michael triumphant over the Devil with the Donor Antonio Juan*, about 1468.

7. Detail of 6.

8. Martin van Heemskerck, *The Virgin and Saint John the Evangelist*, about 1540.

9. Martin van Heemskerck, *The Donor and Saint Mary Magdalene*, about 1540.

OPPOSITE
10. Detail of 9 showing the donor's face.

A similar contrast – if anything even more marked – can be seen in Martin van Heemskerck's two panels showing a kneeling donor with Saint Mary Magdalene [9], and the Virgin with Saint John the Evangelist [8]. Originally these panels would probably have flanked an image of the crucified Christ, which explains the expressions of grief on the faces of the Virgin and saints. However it is not so much their expressions that distinguish the saints from the donor, as the manner in which their faces are conceived and painted. Even the technique with which the donor has been painted [10] – with tight control and small delicate brushstrokes – seems quite different from the freer handling of the paint on the saints' faces. But if the face of Martin van Heemskerck's Mary Magdalene is a stereotype, it is an entirely different one from Bermejo's Saint Michael or Jacopo di Cione's heavenly company.

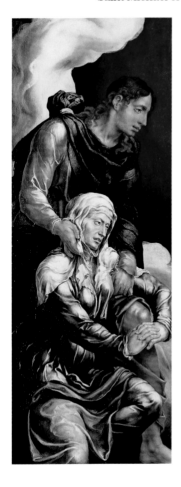
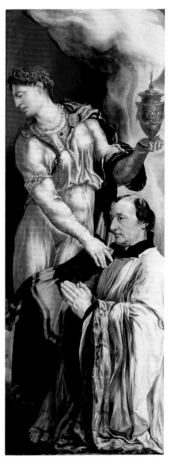

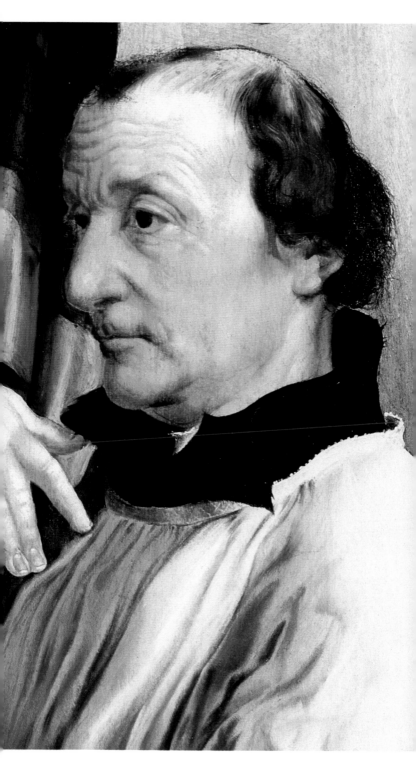

HOW PAINTERS PAINT FACES

Particular painters tend to paint faces in a particular way. We can recognise a Botticelli Venus or a Renoir beauty precisely because of this personal 'handwriting'. The interesting question is where this handwriting comes from. Leonardo da Vinci, when writing about faces, claimed that 'often a master's work resembles himself'; and as the face with which everyone is most familiar is one's own, it would not be surprising if artists unconsciously echoed their own features in the faces they painted. But if there is truth in Leonardo's statement, it is obviously not the whole truth.

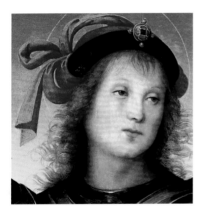

TECHNICAL CONVENTIONS

When Jacopo di Cione started to paint the faces in the San Pier Maggiore altarpiece he would have done so in the way he had been taught. No doubt he would have followed conventions similar to those laid down in Cennino Cennini's practical handbook for painters written at the end of the fourteenth century. Cennino includes a system of outlines and shading as well as offering 'recipes' for the painting in egg tempera of different types of face. He suggested (most famously) that for young faces an artist should use pigments mixed with the yolks of a town-hen's eggs, 'because those are whiter than the ones which country or farm hens produce; those are good, because of their redness, for tempering flesh colours for aged and swarthy persons'.

But it is not only the varying complexions expected in faces that would have been laid down by workshop

11. Detail from *The Archangel Michael*, about 1496–1500, by Pietro Perugino.

12. Detail of 13.

12

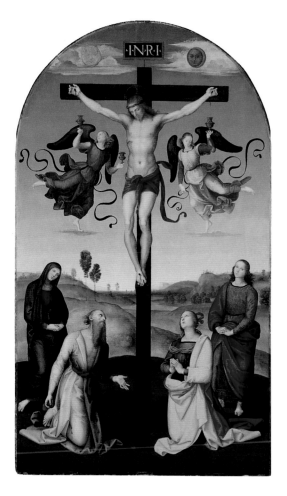

tradition. Conventions of how the face should be shaped could be passed on from master to pupil in a similar way. Cennino, for example, talks about the placing of the 'apples' of the cheeks and notes that: 'My master used to put these "apples" more toward the ear than toward the nose, because they help to give relief to the face.'

One of the clearest examples of a facial type being passed from teacher to pupil is provided by comparing Perugino's *The Archangel Michael* [11] with Saint John in an early painting of the Crucifixion by his pupil Raphael [12]. The earliest biographer of Raphael claimed that it was virtually impossible to distinguish between his early works and those of his master. Certainly the face of Saint John and the other figures in *The Mond Crucifixion* [13] show Raphael's whole-hearted adoption of Perugino's well-established types.

13. Raphael, *The Crucified Christ with the Virgin Mary, Saints and Angels (The Mond Crucifixion)*, about 1503.

13

In the so-called *Ansidei Madonna* by Raphael, painted in 1505, about two years after *The Mond Crucifixion*, the Virgin's face [14] is still recognisably related to Perugino's faces – even if she has acquired more in the way of solidity and animation. Saint Catherine's face [15], painted three years later still, has moved even further from the teacher's prototype. A few years after this, Raphael wrote a much-quoted letter to his friend, Baldassare Castiglione, describing the process by which he arrived at his conception of a beautiful woman:

In order to paint a beautiful woman I would have to see several beautiful women ... But since there are so few ... I make use of a certain idea which comes into my mind. Whether it carries any excellence of art I do not know, but I work hard to achieve it.

Raphael is here explaining how he thinks an artist should paint a beautiful face. The painter should not attempt to copy any real face – real faces are not perfectly beautiful; they will all have imperfections and blemishes. For Raphael and his contemporaries of the early sixteenth century, painting should attempt to reach beyond 'mere' reality, with its idiosyncrasies and accidents of appearance, towards a permanent ideal – a 'certain idea' – the distilled essence of beauty. Of course the question then arises: where can one look for concrete examples of this timeless ideal? For the artists of Raphael's time the answer lay in the art of ancient Greece and Rome. The importance of classical

14. Detail from *The Madonna and Child with Saint John the Baptist and Saint Nicholas of Bari (The Ansidei Madonna)*, 1505, by Raphael.

14

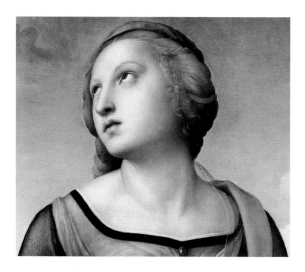

art to the Renaissance was essentially that it was believed to embody precisely these canonic and timeless ideals. Giorgio Vasari, the mid-sixteenth-century artist and author, who also founded the earliest public Academy of Art in Florence, stressed in his *Lives of the Artists* the importance of studying from classical sculpture:

He who has not drawn much nor studied the choicest ancient and modern works cannot ... improve the things that he studies from life, giving them the grace and perfection in which art goes beyond the scope of nature.

For Vasari – just as for Raphael – artists were expected to improve upon reality rather than mechanically record what they saw. And they were to do so according to principles of proportion and beauty learned from their study of ancient art. It was in the degree to which their art went 'beyond the scope of nature' that artists distinguished themselves from mere artisans or craftsmen, who could only slavishly record external appearances. These ideas, formulated in the Renaissance, were of immense and long-standing influence. The championing of the classical ideal lay behind the teaching practice and theory of the artistic Academies founded in Europe from the sixteenth century to the eighteenth. The results can be seen in faces painted throughout the Gallery. When, at the end of the fifteenth century, the young Michelangelo came to paint the two angels on the right of his unfinished

15. Detail from *Saint Catherine of Alexandria*, about 1507–8, by Raphael.

15

16. Michelangelo, *The Virgin and Child with Saint John and Angels* ('The Manchester Madonna'), about 1497.

'*Manchester Madonna*' [16, 17], he gave them the features and curls that one finds in classical sculptures of young gods and heroes such as Apollo and Antinous [18]. From the nineteenth century, essentially the same face and hair can be found again – this time belonging to Oedipus [19] – in the small preparatory study, *Oedipus and the Sphinx*, by Ingres, who later became director of the French Academy in Rome.

The canonic ideals upheld by the Academies of Art embraced not only the art of the ancient world, but also the masterpieces of the High Renaissance, and in particular the paintings of Raphael and Michelangelo. Raphael's ideal of female beauty, for example, itself achieved canonic status and can be found in the

16

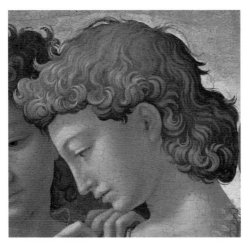

17. Detail of 16.

18. Detail from a
Roman statue of
Antinous, Museo
Nazionale, Naples.

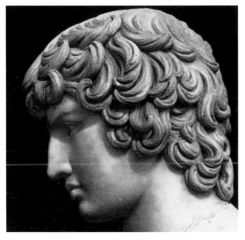

19. Detail from
*Oedipus and the
Sphinx*,
about 1826,
by Jean-Auguste-
Dominique Ingres.

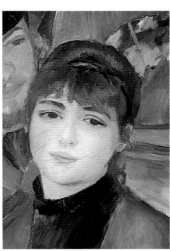

20. Detail from *The Adoration of the Shepherds*, about 1640, by Guido Reni.

21. Detail from *The Virgin in Prayer*, 1640–50, by Sassoferrato.

22. Detail of 23.

seventeenth century in the Virgins of Guido Reni and Sassoferrato [20, 21]. It is even echoed in the moon-faced beauty who stares from Pierre-Auguste Renoir's *The Umbrellas* [22, 23]. Renoir was not trained at the French Academy, and his paintings, together with those of his fellow Impressionists, are usually quite justifiably seen as part of a rebellion against the pre-scriptions of Academic art. But the echo of Raphael in *The Umbrellas* is no accident or coincidence. The picture was painted when Renoir was questioning his own art, with its emphasis on the momentary and

transient effects of nature, and seeking to create something of more permanent value. Started in about 1881, the painting was completed – including the figure on the left – after 1882 when Renoir returned from a trip to Italy. While there he seems to have been most struck by the paintings of the High Renaissance master, and wrote to his dealer in Paris, Durand Ruel: 'I went to see the Raphaels in Rome. They are very beautiful and I should have seen them earlier. They are full of knowledge and wisdom.'

23. Pierre-Auguste Renoir,
The Umbrellas,
about 1881–6.

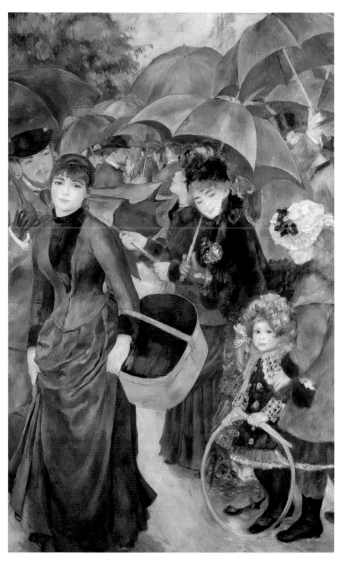

24. Detail of 25.

25. Peter Paul Rubens, *Samson and Delilah*, about 1609.

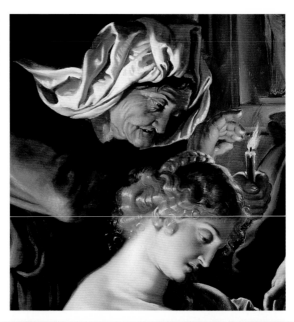

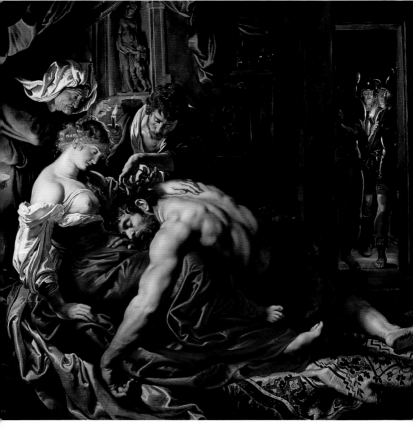

26. Detail from *The Adoration of the Shepherds*, probably 1630s, by an unknown Neapolitan artist.

27. Detail from *Time orders Old Age to destroy Beauty*, 1746, by Pompeo Girolamo Batoni.

Not all repeated facial types found in paintings are ideals – even when they derive from classical art. The old hag in Rubens's *Samson and Delilah* [24, 25], who holds the lamp that lights the barber's work as he deprives Samson of his strength-giving locks, is not an ideal but a stereotype of haggard and toothless old age – even if she does derive ultimately from Hellenistic sculpture. Rubens has deliberately placed this ravaged face beside the beautiful Delilah; and the two women even share certain features such as the curve of their eyebrows and the shape of their noses. The face of the old crone suggests the future of Delilah's beauty – the source of her power over the sleeping Samson. This old woman is not unique to Rubens's painting and she can be found elsewhere in the Gallery. She crops up as an adoring old shepherdess in *The Adoration of the Shepherds* by an anonymous Neapolitan artist [26]; and again, a hundred years later, in Pompeo Batoni's sinister allegory of *Time orders Old Age to destroy Beauty* [27].

28. Hieronymus
Bosch,
*Christ Mocked
(The Crowning
with Thorns)*,
about 1490–1500.

In all of these paintings the facial type helps tell us what sort of old woman this is. In Rubens's painting she is a procuress of a brothel; a peasant in *The Adoration*; and Old Age itself in Batoni's allegory. This toothless face would not be given to a wise old queen or a saint. In narrative scenes artists provide the protagonists with faces fitting to their station. In scenes of martyrdom, such as the Pollaiuolos' painting of Saint Sebastian [76], the idealised features of the saints are often contrasted with the more individualised and brutish faces of their torturers. In *Christ Mocked* by Bosch [28], the four faces that surround Christ's serene features hover on the brink of caricature. Each is a different facial type, but all are vaguely bestial. It is almost as if Bosch deliberately wished to draw parallels between each of these faces and a particular animal; although if this was the case, it is difficult to be certain which animals were intended. Is the man in the red head-dress a goat or a bird? Certainly the bestial nature of the four faces is enhanced by the spiked collar worn by the figure at the top right (which also recalls a common comparison of Christ's torturers with savage dogs).

Drawing parallels between human and animal faces was one of the methods of the pseudo-science of physiognomy, which claimed to be able to read character from the shape and features of the face. A man who resembled a lion would be courageous, a horse wise, and so on. Despite the popularity of physiognomic theories from the Middle Ages well into the nineteenth century, it is difficult to be sure how important these theories were for the painting of faces. Physiognomic treatises – although available in many widely circulated books – tended to be excessively involved; too concerned with minutiae to be of much use to the practising artist. But if academic treatises might provide little help to the painter, the commonplaces of popular physiognomics – such as the still-repeated belief that joined eyebrows denote untrustworthiness – can be found reflected in paintings by Bosch and many others.

Physiognomic ideas about faces – and their reflection of character – are most clearly suggested in painting when they are taken to their furthest extremes – as in the caricatures of *A Grotesque Old Woman* attributed to Quinten Massys [29] or Marinus

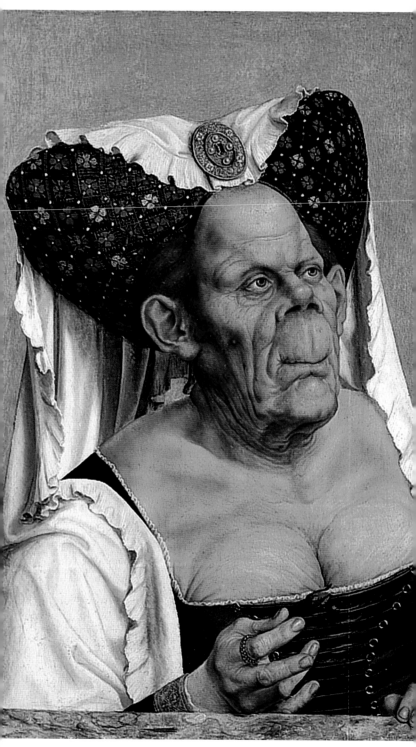

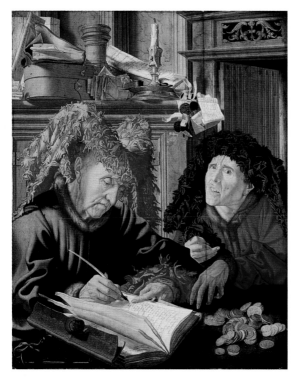

OPPOSITE
29. Attributed to
Quinten Massys,
*A Grotesque Old
Woman,*
about 1525–30.

30. Marinus van
Reymerswaele,
*Two Tax
Gatherers,*
probably about
1540.

van Reymerswaele's *Two Tax Gatherers* [30]. One does
not need to be an expert in physiognomics to recog-
nise the satiric points being made against vanity in
the first and greed in the second. Massys's old woman
is a monstrous creation – her features deliberately
and obviously ape-like – but the joke, such as it is,
lies as much in her low cut dress and elaborate head-
dress as her hideousness. Despite her face and age
she still believes herself beautiful. She holds a rose
bud – symbol of youth, love and beauty – and is
dressed up to the nines, although even her clothes
were out of date by the time the painting was made.
The proud display of her wrinkled bosom suggests
she still hopes to arouse the passions and it is per-
haps this aspect of her character that would have
been most clearly suggested by her simian face. Apes
were long considered particularly lustful creatures,
and in looking at Massys's old lady one might be
unpleasantly reminded of the medieval proverb that
describes a wanton widow as 'a dyvell in the kyttchine
and an ape in her bedde.'

31. Central panel
from *The Virgin
and Child with
Saints and Donors
(The Donne
Triptych)*,
probably
about 1475,
by Hans Memling.

Workshop practice, classical art and physiognomics have not been alone in shaping faces in paintings. Contemporary taste and fashion could influence ideas of beauty and its depiction just as much as the art of the past. This is noticeably more evident in the painting of women than of men. In the fifteenth century, for example – before the classical canon was re-established – high hairless foreheads were considered a particular mark of beauty; and women plucked and shaved their hair in order to achieve these. Paintings of the period not surprisingly reflect this fashion. In the central panel of Memling's *The Donne Triptych* [31] the Virgin, the two standing saints (Catherine on the left and Barbara on the right), and the kneeling Elizabeth (wife of the noble Welsh donor Sir John Donne), are all blessed with the same high domed brows. The same is of course true of Massys's *Grotesque Old Woman* [29] who has

26

obviously plucked *her* brow, but with an altogether different result. But fashion does not merely affect the type of hairstyle that frames the face; it can also dictate the very type of face that is perceived as beautiful. The saints have not only the high domed forehead in common; other characteristics of their faces conform to the ideals expressed in a fifteenth-century poem, *Le Testament*, by the Frenchman François Villon:

… that smooth forehead, that fair hair, those arched eyebrows, those well-spaced eyes, … that fine straight nose, neither large nor small, those dainty little ears, that dimpled chin, the curve of those bright cheeks, and those beautiful red lips.

Painters, however, do not merely reflect ideals of beauty; they help to create them as well. Women today can still be described as 'Titianesque' or 'pre-Raphaelite' beauties – explicitly linking their appearance to an artistic ideal. Recently newspapers carried alarming reports of a woman who visited a plastic surgeon, armed with reproductions of Botticelli's paintings, demanding that her face be recreated in the image of a Botticelli goddess. His Venus, as she appears in the Gallery's *Venus and Mars* [32, title page], presents an image of beauty that is still astonishingly potent; but it is also essentially unreal. Her flawless complexion, the regularity of her features and the smooth contours of her face make it clear that we are looking at an idealised image of beauty rather than a merely beautiful woman.

32. Sandro Botticelli, *Venus and Mars*, about 1485.

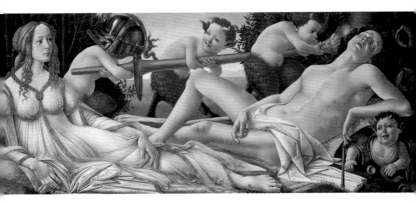

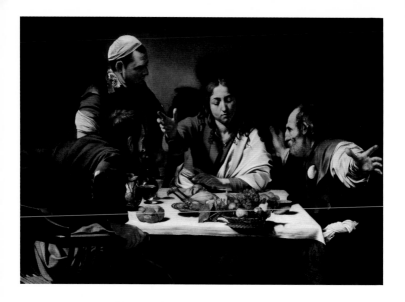

Given that there were accepted and expected ways of painting faces, it was possible for painters to subvert these for particular ends. And Caravaggio, in his *Supper at Emmaus* [33, 34], does precisely this. The painting shows the moment after the Crucifixion when the resurrected Christ revealed himself to two of his disciples by breaking bread and blessing it. Here Christ looks nothing like the ascetic bearded figure of tradition but appears instead as a rather chubby and slightly effeminate youth. In depicting Christ like this, Caravaggio was responding to one of the problems raised by the story he was telling. If Christ had looked as he had always done, how does one explain the fact that his disciples did not recognise him before he broke the bread. However, showing Christ without a beard was not Caravaggio's innovation – he was per-haps following Michelangelo's Christ in his *Last Judgement* in the Sistine Chapel in Rome, which was itself based on an Early Christian tradition. What is exceptional about the face of Caravaggio's Christ, and those of his disciples, is their conscious lack of ideal-isation. It was this deliberate refusal to idealise that shocked Caravaggio's contemporaries. It was not that faces like this had never been painted before; but rather that people were not used to seeing them belonging to disciples – just as they were unused to seeing disciples depicted in torn and ragged contem-porary clothes. Caravaggio took his faces from the

33. Michelangelo Merisi da Caravaggio, *The Supper at Emmaus*, 1601.

34. Detail of 33.

28

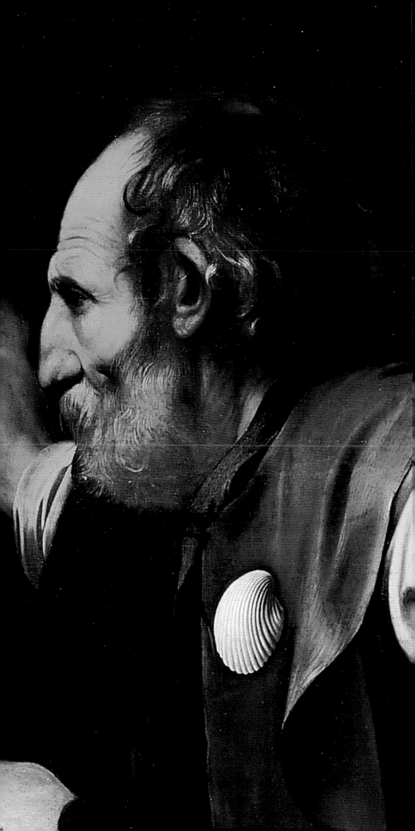

models that posed for him – we can recognise the disciple on the right in other paintings by him – but made no attempt to transform them according to any ideal, classical or otherwise. His critics found this a conspicuous and shocking failing. Caravaggio, they claimed, 'was determined never to make a brushstroke that was not from the life'; and once he had found his models he made 'no effort to exercise his brain further' (Bellori, *The Lives of Modern Artists*, 1672).

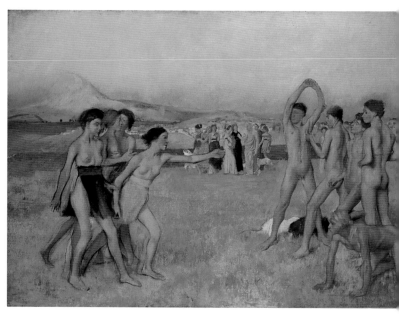

An equally pointed subversion of the ideal can be found over 150 years later in Degas's *Young Spartans Exercising* [35]. In 1859 the twenty-five-year-old Degas returned to Paris from Italy where he had been living and studying for the previous three years. In his notebook of the following year he described a project for a painting which was to show 'girls and boys wrestling in the plane grove, watched by the elderly Lycurgus and the mothers'. The subject was an obscure one – Lycurgus was the mythical lawgiver of ancient Sparta – but that Degas should wish to paint such a picture shows his ambition to establish himself as a history painter in the classical academic tradition. The resulting painting – which seems never to have been finished – is certainly classical in subject matter, but it is remarkably unclassical in spirit. This is almost entirely due to the nature of the young

35. Hilaire-Germain-Edgar Degas, *Young Spartans Exercising*, about 1860.

30

36. Detail of a study for *Young Spartans Exercising*, about 1860, by Hilaire-Germain-Edgar Degas. The Art Institute of Chicago.

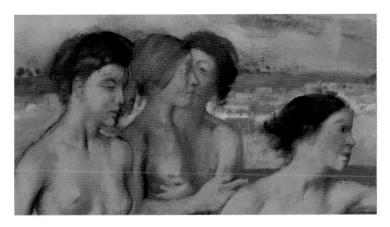

37. Detail of 35.

Spartans' faces [37]. However, this was not always Degas's intention. In the preparatory sketches, the young protagonists were shown with perfect classical profiles [36], and X-rays of the completed work in the National Gallery show that this was originally true of the painting as well. At some time during the picture's history, Degas dramatically changed his approach. In place of the expected idealised profiles, he substituted faces from the real world with snub noses and protruding foreheads. We do not know when these changes were made. The painting remained in the artist's studio for the rest of his life, and he seems to have returned to it on more than one occasion. He even considered exhibiting it, twenty years after it was started, in the fifth Impressionist show of 1880. In descriptions of the painting, the faces of the Spartans are often described as 'modern' or 'contemporary',

which in one sense is obviously absurd – there is no reason to suppose that Spartans in the eighth century BC could not have had faces like this. But they were not expected to do so in nineteenth-century paintings. Just as in the Caravaggio, what is startling is the 'unfittingness' of the faces for the type of person – in this instance, the main protagonists in a classical painting. Degas's faces – undoubtedly based on models in the studio – are deliberately imperfect and possibly worse. The face of the red-haired youth seen in profile on the right [39] has an unnerving similarity to that of the murderer Michel Knobloch whom Degas sketched in the Parisian Criminal Court in 1879, exhibiting the work under the title *The Criminal Physiognomy* [38]. Whether this last parallel is deliberate or fortuitous, what does seem clear is that Degas, in his alterations, was deliberately subverting the classical idealisation expected in such a picture. In doing so, he heralded his own conversion from a painter of histories to the dispassionate observer of modern life.

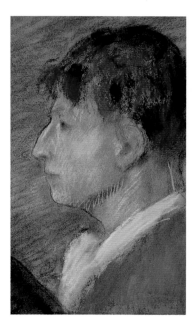
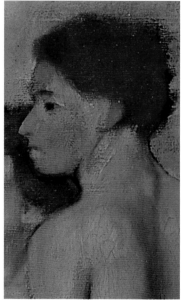

PORTRAITS

PAINTING APPEARANCE

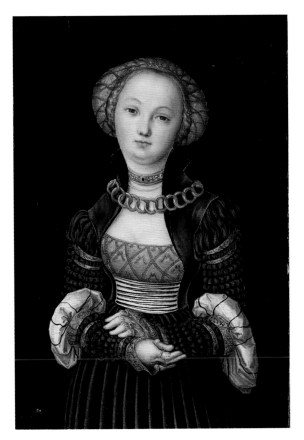

40. Lucas Cranach the Elder, *Portrait of a Woman*, probably 1520s.

The faces we have looked at so far have been, for the most part, faces of characters in 'subject pictures'. When painting the faces of saints or figures from the Bible or ancient history, a painter might be constrained by tradition; but the precise appearance of the face was his or her decision Painters were confronted with a very different problem when called upon to paint faces that actually existed in the real world – in other words, portraits.

The tendency of artists to paint faces in a particular way is often as noticeable in their portraits as in any other kind of painting. In fact it can sometimes be difficult to be certain whether one is looking at a portrait at all or an idealised facial type. Lucas Cranach's *Portrait of a Woman* [40] has all the characteristics

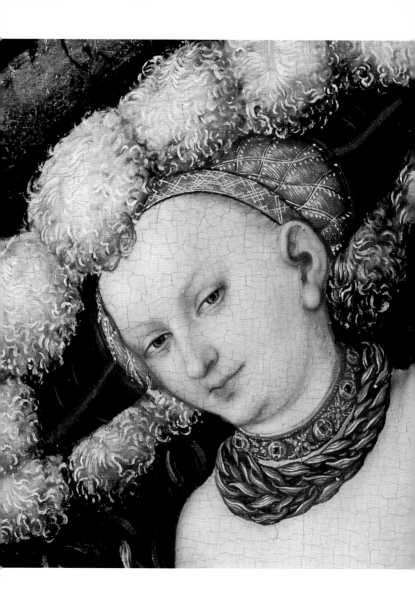

41. Detail from *Cupid complaining to Venus*, probably early 1530s, by Lucas Cranach the Elder.

of his instantly recognisable and idiosyncratic female facial type. Here we find the same broad cheeks, narrow eyes, large domed forehead and incipient double chin that he gives his numerous goddesses and heroines [41, 42]. Indeed it is only the lack of an attribute to identify this woman as a classical or biblical figure

which suggests that this might be a portrait at all. If it is a portrait, it is, of course, possible that the sitter's face happened to conform to Cranach's female ideal; but it is obviously more likely that the artist altered her features – whether consciously or unconsciously – along familiar lines.

42. Detail from *Charity*, 1537–50, by Lucas Cranach the Elder.

43. Hans Holbein the Younger, *Christina of Denmark, Duchess of Milan,* probably 1538.

44. Detail of 43.

In contrast to Cranach's painting, Holbein's depiction of Christina of Denmark [43, 44] appears a model of objective observation. It convinces us that it must have resembled the young princess precisely because her face does not approach any familiar stereotype. The recording of a likeness was crucial to Holbein's portrait. He painted Christina because Henry VIII wanted to know what she looked like and whether she would make a suitable fourth wife after the death of Jane Seymour. The English ambassador to Brussels, John Hutton, had already secured another portrait of Christina by a Netherlandish artist, which he was planning to send to the King, when Holbein arrived in the city. On 12 March 1538 at one o'clock, Christina sat for Holbein who, according to John Hutton, 'havyng but thre owers space hathe shoid hym self to be master of that siens [science], for it is very perffight; the other is but sloberid in comparison...'. In the three hours allotted to him, Holbein would not have had time to paint a portrait, and presumably made a drawing, or drawings, of the Duchess's features and very possibly her famously beautiful hands. The painting would have been worked up later – probably at the request of Henry – who was particularly enthusiastic about the likeness Holbein brought back from Brussels: 'it has singularly pleased the king, so much so that since he saw it he has been in a much better humour than he ever was, making musicians play on their instruments all day long.'

Christina's face is painted with amazing economy. Holbein has reduced it to a few salient features – her neat, narrow mouth, broad-bottomed nose and small widely spaced eyes – but there is nothing generic about these features. Christina's lips in particular are obviously the result of intense looking and careful recording – most clearly seen in the broad curving dip of the upper lip below the septum, the asymmetry of the lower lip and the carefully recorded differences between the two corners of the mouth. It is precisely in such particularities and irregularities of the features that a likeness is to be caught, and portrait painters can often be seen exploiting this fact by exaggerating them – using, with infinite subtlety, the techniques of the caricaturist.

Obviously a grotesquely distorted caricature is not an accurate depiction of the subject's face; yet it is

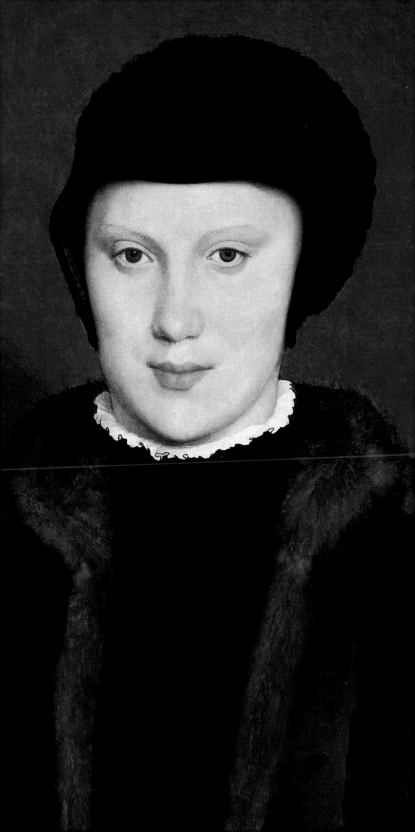

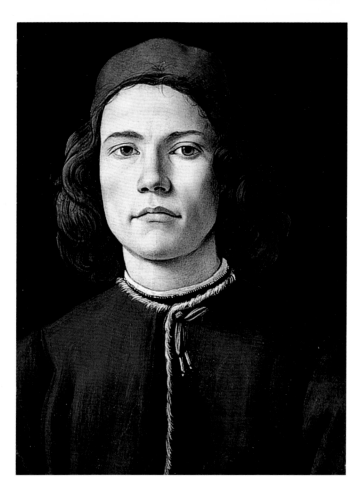

45. Sandro Botticelli, *Portrait of a Young Man*, probably about 1480–5.

immediately recognisable precisely because particular notable features of the face have been wildly exaggerated. Conversely Botticelli's *Portrait of a Young Man* [45] is not grotesque; but the artist has certainly distorted aspects of the face. His features are obviously too large in relation to the size of his face, and their prominence is further exaggerated by the different viewpoints from which Botticelli seems to have painted them. We look straight at the young man's eyes but slightly up at the nose, lips and chin. His lips are completely asymmetrical and one can't help feeling that Botticelli has exaggerated their actual irregularity. This is also true of the eyes which are noticeably different in shape. Despite, or rather because of these apparent distortions, the portrait convinces us that it must have been a striking likeness.

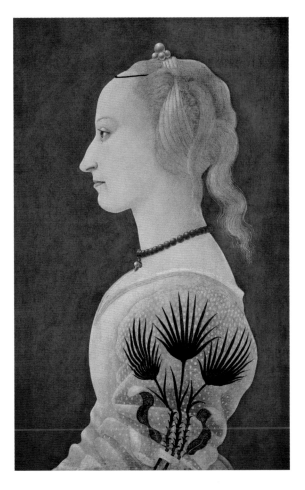

Full-face portraits such as these by Botticelli and Holbein will inevitably emphasise asymmetries of the features and the particularities of the eyes and mouth. In contrast profile portraits – which were favoured in fifteenth-century Italy in emulation of antique coins – concentrate attention onto the shape of the nose and chin. In Baldovinetti's elegant *Portrait of a Lady in Yellow* [46], the distinctive shape of the sitter's nose is carefully delineated. But the portrait, in its chilly remoteness, also makes clear the disadvantages of the profile view, which does not allow for any contact to be made between the sitter and viewer. The great majority of portraits from the fifteenth century onwards adopt an angle of the face between these two extremes and combine the advantages of both. The so-called three-quarter profile view allows

46. Alesso Baldovinetti, *Portrait of a Lady in Yellow*, probably 1465.

39

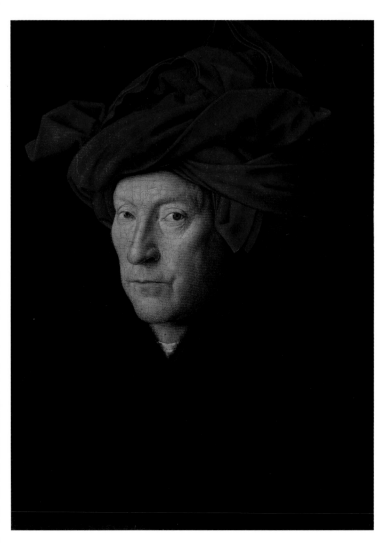

47. Jan van Eyck, *Portrait of a Man*, 1433.

for contact with the viewer, the play upon the features' asymmetries and the description of the nose's profile. In fact the nose in such portraits is often turned slightly more in profile than the rest of the face. By this means its characteristic shape is revealed – a technique noticeable in two of the Gallery's most famous portraits, by Jan van Eyck and by Titian [47, 48]. One might draw other parallels between these two extraordinary paintings; both might possibly be self-portraits, both lavish attention on a feature of the sitter's dress – the elaborate folds of the red chaperon in the one and the quilted satin sleeve in the other. But such incidental similarities only help emphasise

the fundamental differences between the two paintings and the entirely different way the two artists have approached the problem of face painting. Both portraits are almost certainly 'good likenesses' – each artist was much in demand as a portraitist – but they have achieved their ends by entirely different means. Van Eyck has paid meticulous attention to the surface detail of the face in front of him – each hair of stubble, every wrinkle and dimple has been recorded. In contrast Titian has made no attempt to paint every hair or to indicate wrinkles – the beard of the young man melts into his face and attention is instead concentrated on describing the shape of the sitter's face and features; the way the eyes sit in their sockets and the slight curl of the lip.

48. Detail from *Portrait of a Man*, about 1512, by Titian.

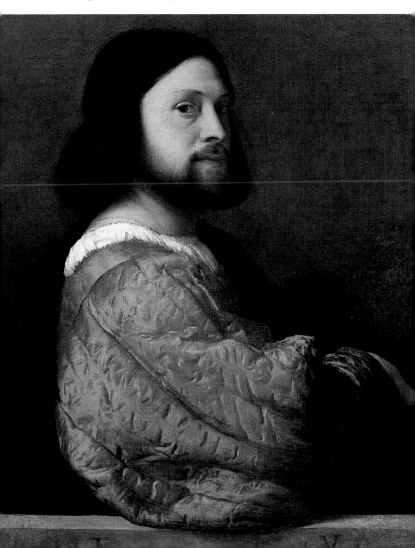

Every artist will approach a face and catch a like-
ness in a particular way, as is seen by comparing
paintings of the same sitter by different artists. To do
this we have to look briefly beyond the walls of the
National Gallery. For example, the Gallery's *Portrait
of Thomas Howard, 2nd Earl of Arundel,* by Rubens
[50] can be compared to a portrait of the same
subject by Daniel Mytens – now housed in Arundel
Castle [49]. The differences between the two faces are
striking and cannot simply be explained by the ten
years or so that separate the two portraits. Mytens is
painting a younger man, but the face is noticeably
more elongated, elegant and refined than the unkempt,
rugged and forceful one painted by Rubens. Despite
these differences, features can be recognised as being
common to both portraits – most noticeably the

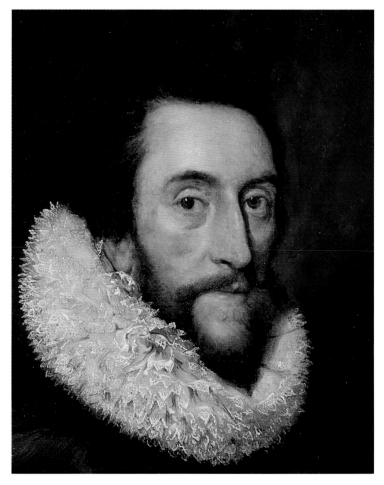

pronounced kink in the bridge of Howard's nose. We sense that if we were to meet Thomas Howard, we would recognise him in both portraits. One only has to consider the wide variety of images of well-known contemporary figures to appreciate this point. For example, the numerous available images of the Queen – photographs, portraits, cartoons, coins, stamps and banknotes – are all wildly different but equally recognisable.

People can be shown in many different ways and remain recognisable, and it seems we do not need many clues to recognise a face – a skilled draughtsman can encapsulate an individual in a few swift pen-strokes. Indeed it is probably easier to catch a likeness in a sketch than in a more painstaking drawing; for the sketch deals only with essentials and

50. Detail from *Portrait of Thomas Howard, 2nd Earl of Arundel,* 1629–30, by Peter Paul Rubens.

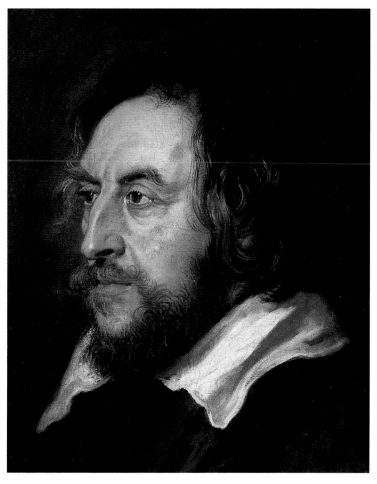

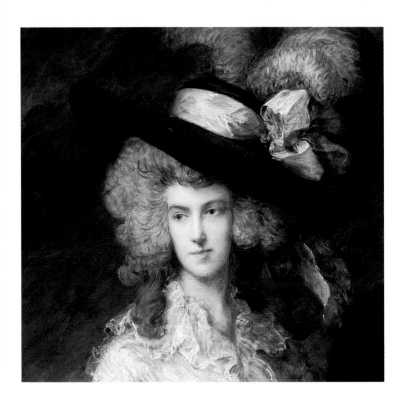

51. Detail from *Mr and Mrs William Hallett ('The Morning Walk'),* about 1785, by Thomas Gainsborough.

provides fewer opportunities for misjudgements which might deviate from the model. According to Reynolds in his *Discourses on Art,* this was essentially the way in which his great rival Gainsborough managed to capture a likeness. Reynolds commented on the sketchiness of Gainsborough's technique and then went on:

I have often imagined that this unfinished manner contributed even to that striking resemblance for which his portraits are so remarkable ... in this undetermined manner there is the general effect; enough to remind the spectator of the original; the imagination supplies the rest, and perhaps more satisfactorily to himself, if not more exactly, than the artist, with all his care could possibly have done.

Reading this passage today, perhaps its most surprising claim is that Gainsborough's portraits were so instantly recognisable, for they seem to possess a family resemblance every bit as marked as the one we have already seen in Cranach's paintings [40. 41, 42]. Mrs Hallett from 'The Morning Walk' [51] and Mrs

44

52. Detail from
Mrs Siddons,
about 1783–5,
by Thomas
Gainsborough.

Siddons [52] – although obviously of very different types and characters – share the long straight nose, dark arched eyebrows and oval heads of so many of Gainsborough's female portraits.

<div style="float: right">LIKENESS
AND
THE IDEAL</div>

Although Reynolds assures us that Gainsborough's portraits were remarkable for their 'striking resemblance', there is undoubtedly a conflict between painting a recognisable likeness on the one hand and the tendency to idealise or revert to a facial stereotype on the other. Most, if not all, portraits negotiate a line between the two. But idealisation along personal, fashionable or canonical lines is not necessarily a shortcoming on the part of the portraitist. Indeed idealisation was often expected; just as facial types in paintings could suggest social standing or status, so sitters for portraits might wish to be painted in a manner fitting to their station, and this might encompass the 'ennobling' of their features. In the sixteenth century the Italian painter and writer Armenini could claim that: 'Portraits by excellent artists are considered to be painted with better style and greater perfection

45

than others, but more often than not they are less good likenesses.' The catching of a likeness, in other words, could be secondary to the creation of a desirable idealised facial type. The kind of 'excellent artist' that Armenini had in mind was probably someone like his near contemporary and fellow Italian Bronzino. Of course, we have no way of knowing if Bronzino's portrait of an unidentified young man [53] is a good likeness or not, but we can recognise that it is a face painted by Bronzino. The alabaster complexion, the large eyes set between smooth unlined eyelids and the shape of the jaw as it rises to the ear, for example, can all be found in the face of the Madonna in his painting of the Holy Family [54]. Bronzino has

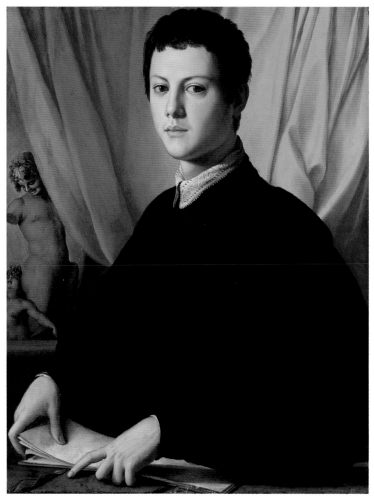

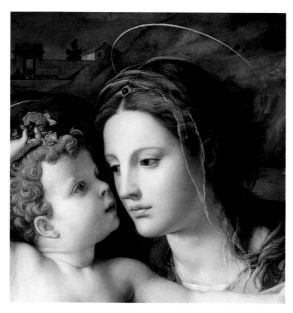

54. Detail from
*The Madonna and
Child with Saint
John the Baptist
and a Female
Saint, probably
Saint Anne,*
probably
about 1540–50,
by Bronzino.

obviously idealised the young man's head, but this is
scarcely a failing. This is the type of face befitting a
young noble – it flatters the sitter but also helps define
the kind of man he is.

To recognise that idealisation was often expected
and desired is not to deny the tension that exists
between idealisation and catching a likeness. It is a
tension that has made itself felt in various ways. For
those artists and theorists who believed that the role
of the artist was to improve upon nature, portraiture
presented a particular problem in that it tied the
painter to the observable world and called upon him
to record what he could see. According to Vasari,
Michelangelo's response to this problem was to paint
only a single portrait because 'he abhorred drawing
anything from life unless it was of the utmost beauty'.
This conflict also helps explain why portrait painting
was considered less elevated than the painting of
'histories' by the Academies of Art. In the nineteenth
century, Ingres complained endlessly about the
demands of his portrait painting, and resented the
time it took him away from the large historical and
allegorical works upon which he saw his reputation
as resting. Today, while many of Ingres's subject
paintings in all their high seriousness teeter on the
edge of absurdity, his portraits astonish. They do so,
one suspects, precisely because of the tensions

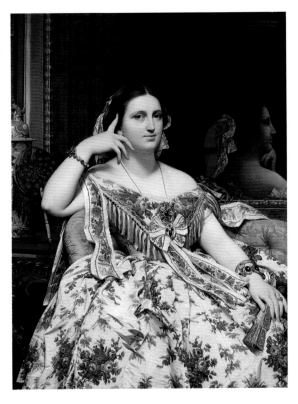

between recording the particular and individual on the one hand, and reaching towards a timeless – essentially classical – ideal on the other. The portrait of Madame Moitessier provides a perfect example [55, 56]. In many respects the young banker's wife is every inch the contemporary bourgeoise. Ingres has lavished attention on the details of her wardrobe, her jewellery and her accessories, and yet the woman within the dress is hardly flesh and certainly not bone. She presents the same alabaster complexion as Bronzino's young man, just as her features offer the same tidy regularity. Her head is supported by a boneless hand in a pose borrowed from a goddess in a Roman wall painting; while the mirror behind – against all the laws of physics – reflects her Grecian, almost Sphinx-like, profile. To ask how old Madame Moitessier is in her portrait is to realise how unhuman and unspecific her portrait actually is. In fact we know that the portrait was painted over a period of eleven years, and so one can quite accurately describe her as ageless. But Ingres has not simply abstracted

48

Madame Moitessier and abandoned the woman of flesh and blood who sat before him. Ironically it was because Madame Moitessier was so close to Ingres's ideals of female beauty that he agreed to paint her at all. When first asked to paint her he refused and only relented when they met. In her he saw a particular type of beauty that was also recognised by Gautier when the writer visited the artist in his studio while the work was in progress: 'Never has a beauty of a type more royal, more splendid, more superb and more Juno like, delivered up its proud lines to the trembling pencil of the artist.'

56. Detail of 55.

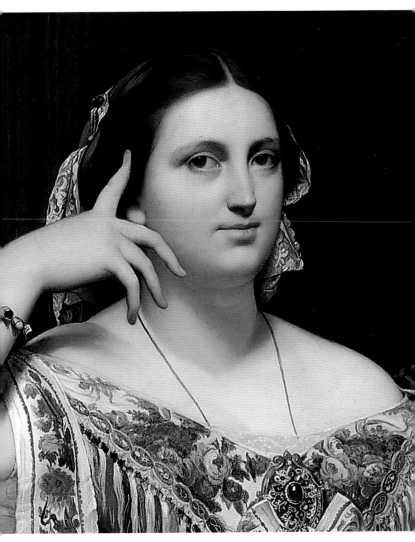

PAINTING CHARACTER

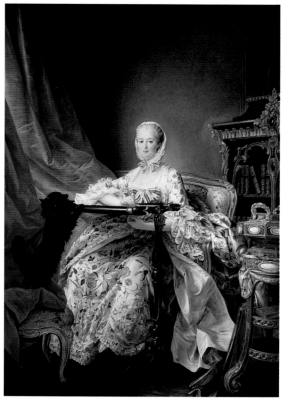

57. François-
Hubert Drouais,
*Madame de
Pompadour,*
1763–4.

The purpose of portraits is not simply to record the outward appearance of the sitter. They are also expected to convey status and character. To achieve these ends portrait painters had recourse to more than just the face. Although, as we have seen, idealisation played its part in establishing social standing, status is even more clearly communicated by dress or the badges of office. Similarly interests and accomplishments can be indicated by props; the casually held book, for example, or the prominent antique sculpture.

SETTING

In Drouais's portrait of *Madame de Pompadour* – the powerful mistress of King Louis XV – her face is far less eloquent than the rest of the painting [57]. Her elaborate dress and gilded furniture, the embroidery frame at which she works, the lute at her feet, the bookcase behind her and even her pet dog Bébé all

contribute to the overall impression of elegant and leisured accomplishment. Madame de Pompadour's face could scarcely tell us as much, although its air of satisfied and plump middle-age contributes to the painting's comfortable and almost homely atmosphere. The portrait is in fact an elaborate fabrication. The signature on the porcelain panel of the fashionable work-table to the right reveals that Drouais painted Madame de Pompadour's face in 1763 – the last year of her life – when she was already ill, vomiting blood and (if we are to believe one witness) with a complexion like sandpaper. What is more, the rest of the picture was painted later still. Madame de Pompadour's elegant surroundings, including her dress, were all painted after her death, when Drouais inserted the earlier canvas on which her face was painted into a larger canvas.

58. Hans Holbein the Younger, *Jean de Dinteville and Georges de Selve ('The Ambassadors')*, 1533.

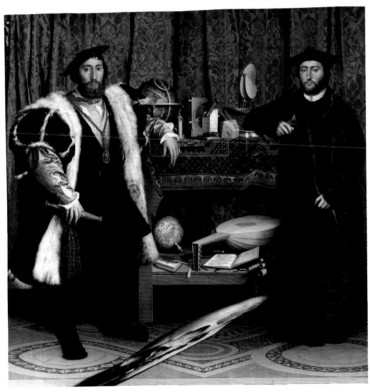

The objects that take centre stage in Holbein's famous double portrait known as *'The Ambassadors'* [58] have been subject to countless involved interpretations. They almost certainly have many

POSE

51

different and overlapping meanings; but one of their functions was undoubtedly to indicate the learning and sophistication of the two Frenchmen in the portrait. But Holbein also exploits many other means of characterising his subjects. The poses of Jean de Dinteville on the left, and the young bishop Georges de Selve on the right, are deliberately and tellingly contrasted. Jean is open and expansive – feet apart, broad shouldered and hands in elegant and languorous repose. Georges appears more cautious; he stands slightly further back and his hands are clenched as he pulls his coat around him. The contrast is as much to do with status as character and is emphasised by the differences of dress. It is as much the expected difference between the knight and the cleric – the active man of the sword as against the scholarly and contemplative man of the cloth – as a contrast of personalities as we understand them.

POSITION

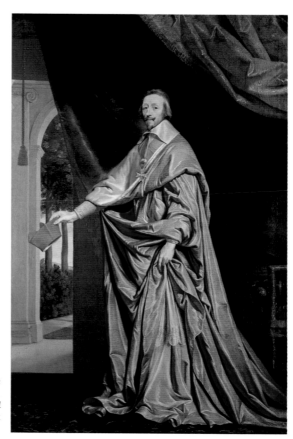

59. Philippe de Champaigne, *Cardinal Richelieu*, about 1637.

52

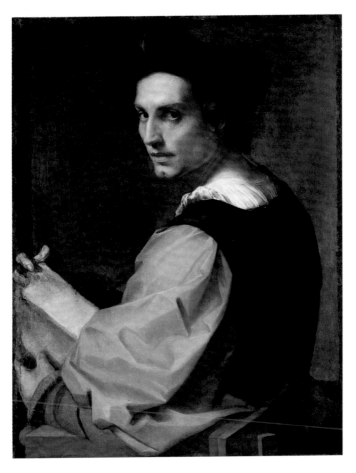

Another means for the portrait painter to convey status and character is the relationship he establishes between the sitter and the viewer. Philippe de Champaigne shows Cardinal Richelieu in the robes of his office and wearing the order of the Saint-Esprit around his neck [59]. But it is our position in relation to him that communicates his importance even more than his dress. Philippe de Champaigne fixes our eye-level in line with Richelieu's right hand – we can for example see up into the crown of the biretta he holds at arm's length. The Cardinal towers above us – an impression emphasised by the extraordinary elongation of his body which is about ten heads high, instead of the proportionally correct seven.

In contrast to Richelieu, the young man painted by Andrea del Sarto in about 1517 [60] is on our level. He twists in his chair to meet our eyes as if we were

60. Andrea del Sarto, *Portrait of a Young Man*, about 1517–18.

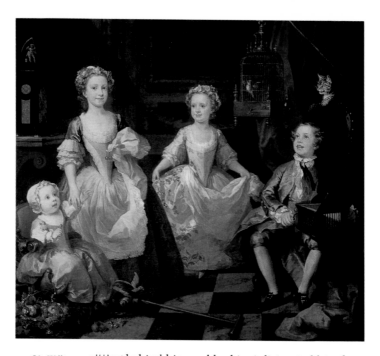

61. William Hogarth, *The Graham Children*, 1742.

OPPOSITE
62. Detail of 61.

sitting behind him and had just distracted him from the book he holds. The effect is forceful and direct, and the impression of energetic intelligence is emphasised by the strong light that falls on his forehead – a much-repeated feature of the portraits of scholars. Such a dynamic pose is unusual in portraiture, partly no doubt a result of the difficulties of holding such a pose; but also because the implied informality was not fitting or desired by most sitters.

THE EXPRESSIVE FACE

Whatever the communicative potential of the pose, dress and other elements of a portrait, we naturally look to the face for suggestions of character. However it is much less clear what we are looking for. We might look for expressions of mood and emotion, but just as dynamic poses are rare in portraiture so are pronounced facial expressions. Even smiles are rare, and where they do appear, as in Holbein's *Christina of Denmark* [44], they are slight and close-mouthed. There is seldom a flash of teeth. In Hogarth's portrait of *The Graham Children*, it is true, the young Richard laughs with pleasure as he torments the unfortunate caged bird with his musical box [61, 62]; but this playful informality was permitted in portraits of children.

54

The avoidance of marked facial expressions was dictated not only by decorum but also by a more fundamental difficulty in depicting them. A smile is fleeting – when called upon to hold a smile ('say cheese'), it swiftly turns into an unnatural grimace. A painted expression might seem natural and spontaneous at first glance, but as we continue to look it may well appear increasingly stilted and inane. But if pronounced expressions are avoided in portraiture, painters have adopted various other devices to give faces the illusion of animation. The asymmetries of the features that we have seen helping to capture a likeness can also suggest an expression playing across a face. Van Dyck's extraordinarily lively portrait of Cornelis van der Geest [63], the wealthy spice merchant and patron of the arts, is a fine example. The differences between the two sides of the face are marked – seen, for example, in the size of his eyes – and are emphasised by the ruff framing his face with playful curves on the right (echoing both his ear and the wave of his hair), contrasting with a whiter, flatter arrangement on the left. The contrast between the two sides of the face is also one of expression; an incipient smile seems to play on the right side of his mouth, as we look at it, picked up by the creases around his eye. The left side of his face, in contrast, appears more severe. His lips almost move (they seem slightly parted), and here Van Dyck uses another device to avoid stiltedness. He refuses to be specific. The corners of the mouth cannot be fixed and their precise positions remain uncertain beneath the gauze of the moustache.

EYES

Much of the force of Van Dyck's portrait lies in the penetrating gaze with which van der Geest fixes us, and it is to the eyes – 'the windows of the soul' – that we most naturally look for illumination as to character. Eyes can vary in appearance. For example, in *The Ambassadors'* [58] the contrast between the wider, whiter, brighter eyes of Jean de Dinteville and the heavy lidded and duller ones of Georges de Selve reinforces the other contrasts drawn between the two men. Usually, though, it is what the eyes are doing – rather than what they look like – which reveals most in portraiture. Eyes in portraits can either look out at the viewer, or not; but they can do either in many

56

different ways. Cornelis van der Geest looks straight
at us, making him appear forthright, open and frank.
Andrea del Sarto's young man [60] swivels his eyes as
he turns his head, as if eager to meet our gaze. The
young noble painted by the sixteenth-century northern
Italian Moroni [64, 65] also looks out at us from the
corner of his eyes – but with an entirely different

63. Anthony
van Dyck,
*Portrait of Cornelis
van der Geest*,
about 1620.

57

64. Detail of 65. result. Here the action of the eyes is not part of some greater movement – indeed the effect is of someone who cannot be bothered to turn his face towards us, and it carries with it the impression of aristocratic disdain. In other portraits, Moroni uses the eyes to equally telling effect. In the portrait known as 'The Lawyer' [66], the sitter tips back his head to peer at us down his nose, while in marked contrast 'The Tailor' [67] looks up at us with a deferential tip of the head, scissors held ready to cut his cloth to suit us.

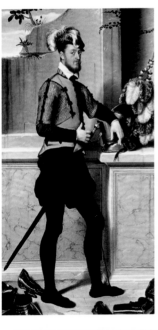

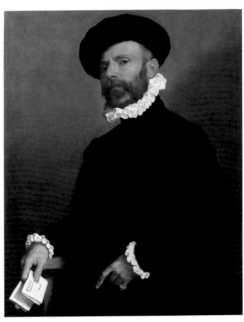

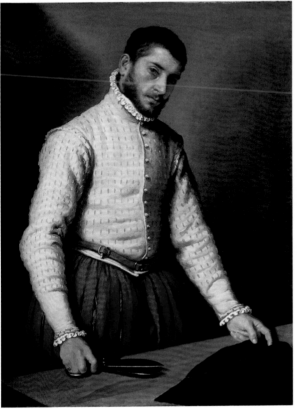

65. Giovanni Battista Moroni, *Portrait of a Gentleman (Il Cavaliere dal Piede Ferito)*, probably about 1555–60.

66. Giovanni Battista Moroni, *Portrait of a Man holding a Letter ('The Lawyer')*, probably 1570–5.

67. Giovanni Battista Moroni, *Portrait of a Man ('The Tailor')*, about 1570.

68. Details of 50,
69, 66, and 67.

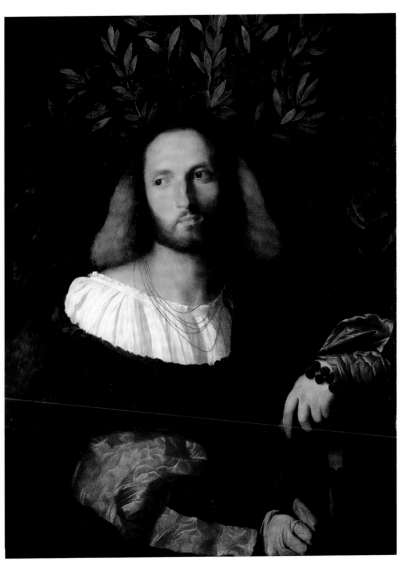

When eyes do not look out directly at the viewer, the possibilities are equally various and telling. In Rubens's portrait of the Earl of Arundel [50] the sitter stares straight ahead, his eyes in line with his face, to convey the impression of forcefulness and strength of purpose. In contrast, Palma Vecchio's young man [69] stares off into space, his eyes out of line with his face, suggesting contemplation and reverie. We do not really need the clue provided by the laurel leaves – symbols of poetry which sprout behind him – to conclude that this is the portrait of a poet.

69. Palma Vecchio, *Portrait of a Poet (Ariosto?)*, about 1516.

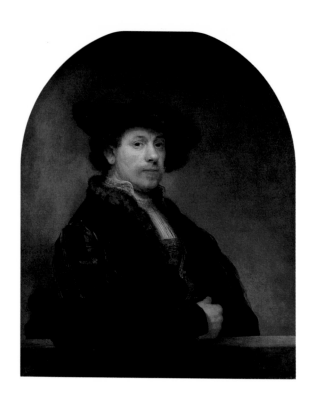

There is a danger of oversimplification when discussing the reading of character into faces, of talking as if there were a straightforward language by which a painted face can convey character, as if eyes looking in one direction unambiguously produce a specific effect in the viewer. But faces and their expressions are far less transparent than this. Indeed one person's reading of a face within a portrait is often flatly contradicted by another's opinion. For example, I have characterised the face of Moroni's gentleman [64] as suggesting aristocratic disdain; but the same face could be read either as shifty or shy. Much of what is read into faces comes down to our own prejudices, or opinions, and what we expect to find there. My belief that a sixteenth-century noble would have been more likely to want to convey aristocratic hauteur than anxious shiftiness affects how I read his face; but a different assumption could lead to a different reading.

A comparison frequently made between Rembrandt's two self-portraits in the National Gallery illustrates the same point [70, 71]. The earlier portrait was made when the painter was thirty-four and at the

70. Rembrandt,
*Self Portrait at the
Age of 34*, 1640.

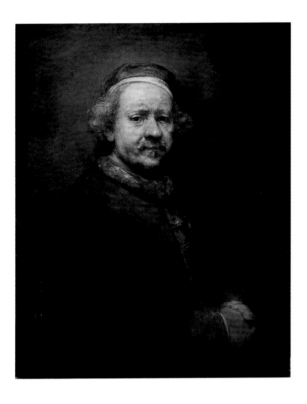

height of his fame and success as a painter in Amsterdam. With supreme self-confidence he has shown himself as a Renaissance gentleman, dressed in deliberately archaic clothes and adopting the pose used by Titian in his *Portrait of a Man* [48]. In Rembrandt's time this painting was believed to be of the Renaissance poet Ariosto, and Rembrandt may have seen it, as it was then in an Amsterdam collection. The later self-portrait, in contrast, was painted in the year of Rembrandt's death – 1669. The artist's last years are usually characterised as ones of personal sadness, professional set-backs and financial difficulty. In 1656 Rembrandt had been declared a bankrupt; in 1663 his mistress Hendrickje Stoffels died, to be followed in 1668 by his only son Titus. In looking at this late self-portrait, it is only natural to try to read some of this information, and see it as a record of sad and disappointed resignation. But although Rembrandt has recorded his ageing features with dispassionate accuracy, we should perhaps hesitate before judging his intentions. A closer inspection reveals that the clothes in which he is dressed (fur-lined and gold-

71. Rembrandt,
Self Portrait at the Age of 63, 1669.

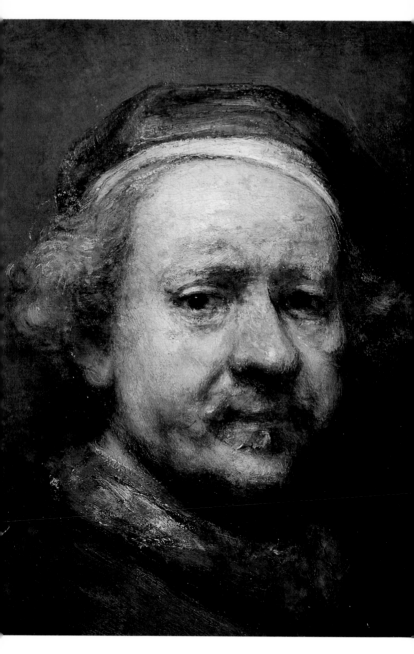

72. Detail of 71. buttoned), are almost as elaborate as those in the earlier portrait – even if less attention is lavished upon them. More importantly, can one really say there is anything in the elderly Rembrandt's expression that could not be read as suggesting a quiet pride and assured satisfaction with his lifetime's achievement?

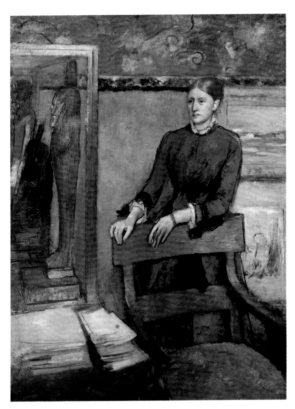

73. Hilaire-
Germain-Edgar
Degas, *Hélène
Rouart in her
Father's Study*,
about 1886.

Such ambiguities are scarcely failings. Indeed it is
precisely because of them that portraits still fascinate,
even when the identity of the sitter has been lost. In
other instances artists have exploited the inevitable
ambiguity of the face, as Degas does to disturbing
ends in his portrait of Hélène Rouart [73]. Outwardly,
Degas's portrait seems similar in its aims to Drouais's
Madame de Pompadour. It shows a woman, painted
life-size, surrounded by objects that appear to reflect
her accomplishments and interests. A painting and a
drawing hang behind her. On the desk are piles of
books and papers and a glass case containing various
Egyptian statues. But the portrait is not so simple.
Hélène was the daughter of Degas's great friend Henri
Rouart, the industrialist, artist and collector, and she
is not shown surrounded by her own possessions but
in her father's study. All the objects around her are
his, including the enormous chair which acts as both
a support and a barrier. How are we to read Hélène in
these surroundings? Did Degas intend to depict her

74. Detail of 73. 'at home' in this cultivated setting as an embodiment
of 'completeness and serenity' (to quote one descrip-
tion of the painting), or as a young woman 'stifled by
her surroundings', as others have claimed? As a
friend of both daughter and father, one suspects
Degas would have recognised the truth in both read-
ings; and surely his wilfully unspecific treatment of
Hélène's face [74] – both serene and calm, yet sad and
longing – deliberately exploits this ambiguity.

THE EXPRESSION OF
THE EMOTIONS

If the ambiguities of facial expression can be an advantage for the portrait painter, the same is not always true for the painter of narratives. The communication of emotional states through the depiction of facial expression and gesture was long considered an essential component of painting. Leonardo da Vinci warned that a figure without a lively expression in a painting would appear 'twice dead' and claimed:

The good painter has two principal things to paint, that is man and the intention of his mind. The first is easy, the second difficult, because it has to be represented by gestures and movements of the body.

A generation earlier the artist and theorist Alberti, in his treatise *On Painting*, laid equal stress on the importance of the accurate depiction of expression. For Alberti, painting's ability to move the beholder was an essential part of its claim to be an equal of poetry – a liberal rather than a mechanical art. This power to move derived from the way in which painting could depict the emotions:

A narrative will move spectators when the men painted in the picture outwardly demonstrate their own feelings as clearly as possible ... we mourn with the mourners, laugh with those who laugh and grieve with the grief-stricken.

But although the desire to depict the emotions was there, achieving these ends was more of a problem, as Alberti himself admitted, evidently from bitter experience:

Who, unless he has tried, would believe it was such a difficult thing, when you want to represent laughing faces, to avoid them appearing tearful rather than happy.

For both Alberti and Leonardo the solution to this problem lay in the careful observation and recording of the natural world. Leonardo suggested that the artist should take his sketchbook into the street and surreptitiously observe and record the natural

75. Detail from *The Way to Calvary*, about 1324–5, by Ugolino di Nerio.

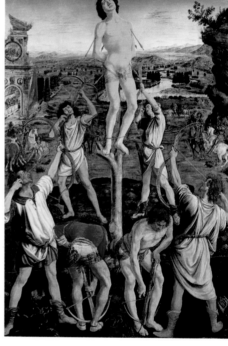

76. Antonio and Piero del Pollaiuolo, *The Martyrdom of Saint Sebastian*, completed 1475.

77, 78. Details from 76.

gestures and expressions of people as they went about their daily business.

Paintings in the National Gallery by Leonardo's predecessors reveal an ever-increasing attention to the details of facial expression. A painting from the fourteenth century, such as Ugolino di Nerio's predella panel of *The Way to Calvary* [75], shows a very limited repertory of expressions – even if they are easily understood within their context. The faces of Christ and the holy women on the left are given very basic expressions of sorrow, while his torturers display a similarly generic face of cruelty; and the contrast between the two predominant expressions is achieved simply by altering the slope of the eyebrows.

The Martyrdom of Saint Sebastian [76], painted a century and a half later by the Pollaiuolo brothers, reveals an entirely different kind of observation. Most striking of all is the contorted red face of the archer bending down to load his crossbow [78]. Painted from an awkward angle this is a remarkably successful attempt to characterise both the archer's vicious nature and the straining concentration he is giving to his task. When Vasari saw this figure in the mid-sixteenth century he admiringly claimed that one could tell that the archer was holding his breath.

The Pollaiuolos' painting can be seen in many ways as a direct response to Alberti's call for the observation of the natural world. But if the grimaces of the archers convince, the expression of Saint Sebastian himself is of a different order [77]. This is largely a response to the same demands of decorum we have seen affecting facial types: saints would be expected to be more restrained and elevated in their

79. Detail from *Saint Mary Magdalene*, about 1634–5, by Guido Reni.

69

expressions than their tormentors. But Sebastian's expression is also more the result of convention than observation – which is hardly surprising as there were few opportunities to observe saints being martyred. There is a story that when the seventeenth-century sculptor Bernini was working on a scene of the martyrdom by burning of Saint Lawrence, he stuck his arm into the fire while observing his expression in a mirror. But even if the story was believable such dedication to authenticity could scarcely be expected of the artist. Simply because Sebastian's expression is conventional does not mean it fails communicate its meaning. Indeed we understand it at once precisely because of our familiarity with its use in paintings.

By the seventeenth century, the desire to master the representation of expression was deep and wide-spread, and it has been described as the central preoccupation of the artists of the time. Rembrandt's only surviving utterance on his artistic aims, in a letter of 1639, speaks of his desire to capture 'the greatest and most natural emotion' and *Belshazzar's Feast* [80, 81], painted about a year earlier, can be seen as a painting of emotional extremes. Belshazzar has just sprung to his feet, his arms flung outwards have knocked cups and guests flying as he turns to confront the writing on the wall and the disembodied hand that has traced it. His eyes bulge from their

OPPOSITE
80. Detail of 81.

81. Rembrandt
*Belshazzar's
Feast*, about
1636–8.

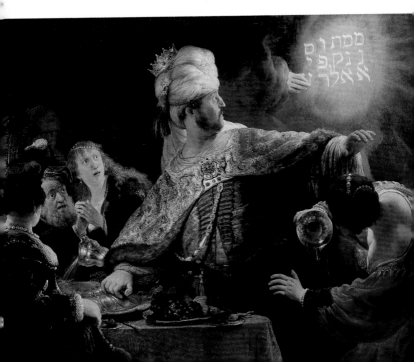

sockets in exaggerated terror, while his companions – apparently as yet unaware of the cause of his terror – stare at him wide-eyed and open-mouthed. The emphasis on the sudden and extreme reaction is taken directly from the account of the feast in the Old Testament (Daniel 5: 6) which stresses Belshazzar's physical and emotional response to the vision:

Then the king's countenance was changed, and his thoughts troubled him, so that the joints of his loins were loosed and his knees smote one against another.

82. Annibale Carracci, *The Dead Christ Mourned ('The Three Maries')*, about 1604.

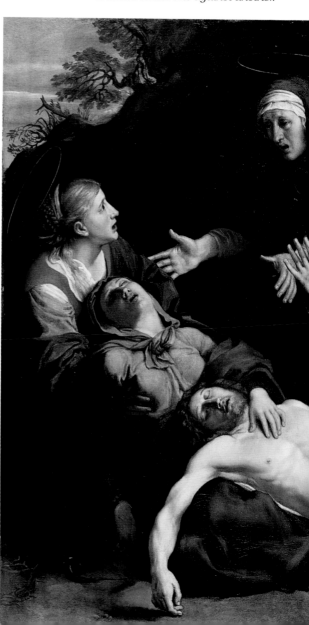

A similar concern for the details and varieties of facial expression can be seen in Annibale Carracci's *The Dead Christ Mourned*, painted in about 1604 [82]. The four grieving women grouped around the body of the dead Christ are differentiated in the form and intensity of their grief. The Virgin, slumped back, takes on the pose, pallor and expression of her dead son in an extreme of compassion (which literally means 'suffering with'). The other three holy women are each given a different focus for their grief, while their facial expressions are deliberately modulated,

83. William
Hogarth, *Marriage
A-la-Mode: III,
The Visit to the
Quack Doctor,*
before 1743.

from the look of anguished concern of the woman who looks up for help as she supports the Virgin, to the intense suffering of Mary Magdalene in red, as she alone contemplates the dead body of Christ.

The desire to master the different degrees of emotional expression reached its apogee in the seventeenth century with the lectures given to the French Academy in 1668 by its president Charles Le Brun. Le Brun attempted to categorise the emotions, and explain the expressions they gave rise to, according to scientific principles. He based his theory on the belief – propounded by the philosopher Descartes – that the soul was situated in the pineal gland behind the forehead and that expressions were caused by the flow of 'animal passions' from the soul around the circulatory and nervous systems. Le Brun's lecture went into sixty-three separate editions, but its influence lay less in the detail of his theories, than the illustrations of expressive heads that accompanied the text [84, 85].These were used by artists as a sort of 'pattern book of the expressions' in the eighteenth century. Hogarth described the book disparagingly as 'the common drawing-book ... for the use of learners'; but one should treat Hogarth's dismissive tones with caution. Although he could not help being rude about the

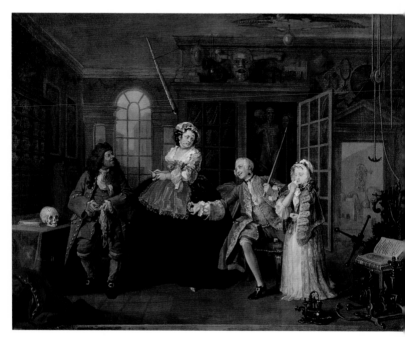

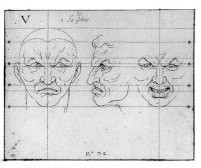

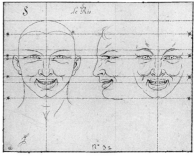

French, some of the expressive faces in his series of paintings, *Marriage A-la-Mode,* are suspiciously close to those of Le Brun. For example, the faces of the quack doctor's formidable female assistant [86], and that of the young count [87] in the third painting of the series [83], seem very close to Le Brun's formulae for 'Anger' and 'Laughter' [84, 85] respectively.

84. Charles Le Brun, *Anger,* 1668 Paris, Musée du Louvre.

85. Charles Le Brun, *Laughter,* 1668, Paris, Musée du Louvre.

BELOW
86, 87.
Details of 83.

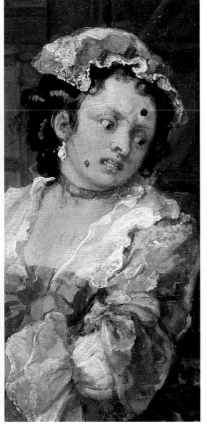

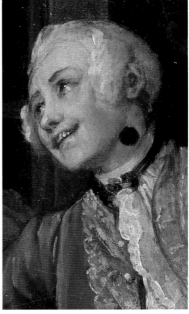

The successful communication of emotional states through the depiction of emotions is, however, more problematic than Le Brun or his predecessors would have us believe. Photography has revealed that the difficulty does not lie so much in the accurate recording of an expression as in the ability of the viewer to recognise it. In other words – to adapt Alberti's example – even a photograph of a laughing man can be mistaken for a crying one. Expressions are movements; and what is more they are movements from the position of the face at rest. The expressive movements of a person with a natural frown will inevitably appear different from one without, but static images of expressions cannot give us this information.

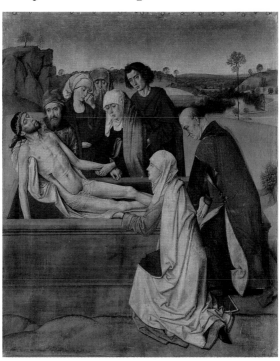

88. Dieric Bouts, *The Entombment*, probably 1450s.

Painters can provide us with other information, of course – the context of an expression means that we seldom mistake the painter's intention.

The importance of context in reading expression is such that we are inclined to read expressions even into neutral faces when supported by other factors. While one tradition of expressive painting attempted to depict the peaks of emotion, another tradition has exploited our tendency to read emotion into faces

when provided with the slightest of clues. *The Entombment* by the Netherlandish painter Dieric Bouts [88] was painted about twenty years before the Pollaiuolos' *Martyrdom of Saint Sebastian* [76]. The difference in approach is marked. Where the Pollaiuolos are concerned with extremes, Bouts's painting is an exercise in restraint. One of the holy women lifts her headdress to wipe tears from her cheek; behind her another covers her mouth. But these are the only explicit gestures of grief. The faces of those who place Christ into his tomb show none of the anguished contortions displayed, for example, in Annibale Carracci's *The Dead Christ Mourned* [82]; yet they effortlessly convey their profound sorrow. That they do so has

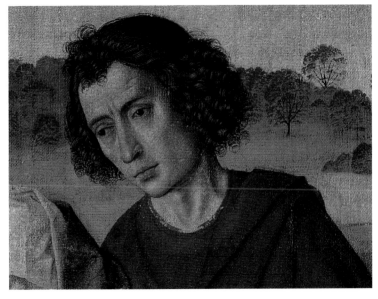

everything to do with context. The face of John the Evangelist, for example, taken in isolation [89], could be seen as puzzled, worried or even annoyed; but none of these possibilities survive once he is seen within the painting. The contrast between the Bouts and the Carracci is one both of key and convention. The difference is similar to that between the melodramatic gestures of actors in early silent films – adopted from earlier stage conventions – and the technique of many contemporary film stars, who let the audience project profound emotion onto a scarcely moving face. Bouts, with instinctive understanding, has exploited our tendency to read more into faces than is actually visible.

89. Detail of 88.

CONCLUSION

THE BLANK FACE

Our sensitivity to faces in paintings is as great as it is in life. No face in a painting can fail to communicate with us – even the most apparently neutral face will express something. What this is, however, will depend upon who is looking at the painting. Painters have controlled our response to faces in various ways. They have adopted conventional and recognisable facial stereotypes; they have placed the face in a particular and clearly defined context; or attempted to depict specific expressions. But they have also exploited the ambiguity within faces, and our instinctive and uncontrollable tendency to 'read' them.

In Seurat's famous painting of *Bathers at Asnières* [90], the faces of the principal figures are all obscured. On the right the boy in the red hat brings his hands over his mouth to shout or whistle; the boy in the water behind him turns away from us. On the bank a straw hat covers the eyes of one figure, while the face of the figure lying in the foreground is hidden by his jutting shoulder. However, it is the face of the central

90. Georges-Pierre Seurat, *Bathers at Asnières*, 1884.

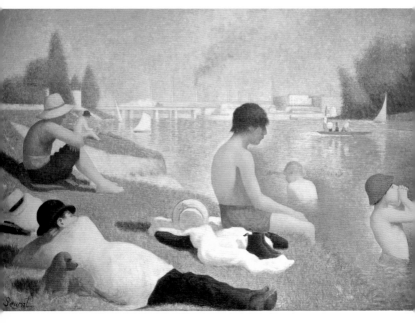

figure – legs dangling in the water – which is most curiously obscured [91]. His face should be in bright sunlight (his head casts a shadow on the bank behind him), but Seurat has deliberately refused to illuminate it. We look to his features for an idea of his state of mind, but the blank face allows us to impose our mood on it. And this can vary depending on whether we see the painting as a scene of sunny relaxation, or one of isolated and alienated boredom in which no one talks or communicates with anyone else. If Seurat had defined the faces of the figures in the painting, this uneasy sense of uncertainty would have been lost. In his treatment of the features in the *Bathers,* Seurat has recognised and exploited the way we read faces. The more information we are given, the more our response is manipulated and circumscribed. Even when we are given no information, we cannot help imposing feelings, sensations and character upon a face – and hence upon the painting in which it appears. Faces in paintings will always communicate with us. But in some instances, as Seurat demonstrates, what they seem to communicate is actually what we bring to them.

FURTHER READING

SOURCES QUOTED IN THE TEXT

Alberti, Leon Battista, *On Painting*.

Cennini, Cennino d'Andrea, *The Craftman's Handbook: 'Il Libro dell'Arte'*, translated by Daniel V. Thompson, Jr., New Haven and London 1933; repr. 1954.

Richter J.P. (editor), *The Literary Works of Leonardo da Vinci*, 2 vols, 3rd ed., London 1970.

FURTHER READING

Brilliant, Richard, *Portraiture*, London 1991.

Bruce, Vicki and Young, Andy (editors), *In the Eye of the Beholder: The Science of Face Perception*, Oxford 1998.

Campbell, Lorne, *Renaissance Portraits: European Portrait Painting in the 14th, 15th and 16th Centuries*, New Haven and London 1990.

Chapman, H. Perry, *Rembrandt's Self-Portraits*, Princeton 1990.

Gombrich, Ernst H., *Art and Illusion*, London 1960.

Gombrich, Ernst H., 'The Mask and the Face: The Perception of Physiognomic Likeness in Life and in Art', in E. H. Gombrich, *The Image and the Eye*, Oxford 1982, pp. 40–62.

Gombrich, Ernst H., 'Ritualized gesture and expression in art', in E. H. Gombrich, *The Image and the Eye*, Oxford 1982, pp. 63–77.

Gombrich, Ernst H., 'Ideal and Type in Italian Renaissance Painting', in E. H. Gombrich, *New Light on Old Masters: Studies in the Art of the Renaissance IV*, Oxford 1986.

Jennifer Montagu, *The Expression of the Passions: The Origin and Influence of Charles Le Brun's 'Conférence sur l'expression générale et particulière'*, New Haven and London 1994.

Pointon, Marcia, *Hanging the Head: Portraiture and Social Formation in Eighteenth-Century England*, New Haven and London 1993.

Portraits by Ingres: Image of an Epoch, forthcoming exhibition catalogue by Robert Rosenblum and others, New York, Metropolitan Museum of Art, Washington, National Gallery of Art and London, National Gallery 1999.